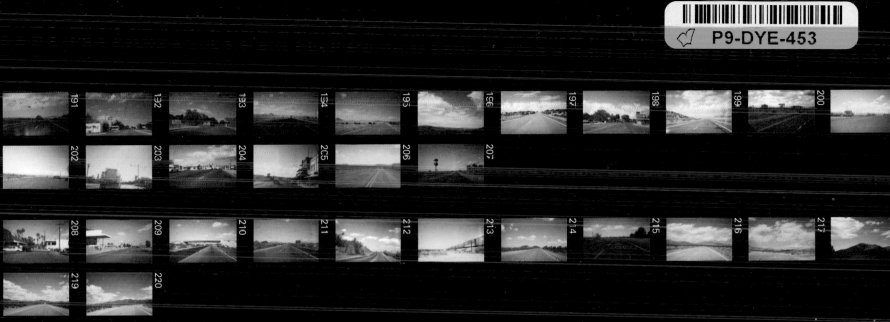

DAY 19

Marking the Land 1

Marking the Land 1

Photographs by Melissa Cicetti

Introduction by Barbara Buhler Lynes

University of New Mexico Press | Albuquerque

08 07 06 05 04 1 2 3 4 5

Printed in Singapore

Library of Congress Cataloging-in-Publication Data

Cicetti, Melissa, 1967–
 Marking the land 1 / photographs and text by Melissa Cicetti ;
introduction by Barbara Buhler Lynes.
 p. cm.
 Includes bibliographical references.
 ISBN 0-8263-3238-2 (pbk. : alk. paper)
 1. Architectural photography—Southwestern States.
2. Southwestern States—Pictorial works.
3. Cicetti, Melissa, 1967–
I. Title.
 TR659.C39 2004
 779'.479dc22
 2004019729

book design and type composition | Kathleen Sparkes

type used throughout the book is the Zurich family
display type is Helvetica Neue Thin

This book was printed by TWP America, Inc. in Singapore

to Pop and Lucy

Contents

Introduction

There are eighty-nine black and white photographs in Melissa Cicetti's *Marking the Land 1.* These images provide a fascinating visual record of specific moments of a twenty-three–day road trip she made in 2000 while wending her way along Route 66 and numerous other roads and highways that cut through the vastness of the American Southwest. In photographing sites separated from one another by hundreds of miles, she sought to explore and expand her understanding of the meaning of "place," which she characterizes as sites made specific by the interaction between various areas of the land and the human-made forms that have been imposed upon them.

She first become fascinated with this concept through coursework in design and the environment as a student at the University of Pennsylvania, where she obtained a BA in 1989 and a Master's Degree in Architecture in 1993. At the time, she made photographs of sites that interested her. In the process of studying her developed prints, she discovered that they

revealed relationships between natural and manufactured forms that she had been unaware of while making them. Such realizations helped her refine her ideas about the concept of place and her relationship to it.

In her subsequent work as an architect in New York, Cicetti became increasingly absorbed in solving practical problems. By the late nineties, she realized she had lost touch with the process through which she had come to understand the concept of place, the issue that had first drawn her to the study and practice of architecture. In an effort to re-engage in this concept and to deepen her understanding of it, she applied for and received a grant from the New York City chapter of the American Institute of Architects to make a photographic study of the ways in which humans had marked the land in New Mexico, Arizona, and California.

She set out from Santa Fe, New Mexico, and ended her trip some three thousand miles later on the beaches of Santa Monica, having had no set idea of what sites she would photograph along the way. She preferred instead to capture subjects to which she was drawn intuitively. Cicetti selected the prints in *Marking the Land 1* from approximately five hundred images taken on the road. She titled them according to the day of her trip and where she was, as in "day 1, route 285 south towards Lamy, New Mexico, 1:12," and the numbers following her descriptive title refer first to the roll of film she was using and then to the number of the exposure on the roll. She then

arranged her photographs in a chronological sequence of moments that chart her place in and movement across the land.

In spite of the arbitrariness of her approach to subject matter, several motifs appear frequently in her work. For example, more than half of the photographs include architectural forms, such as barns, churches, gas stations, hotels, houses, and silos. Most are of abandoned structures that are in various stages of falling apart. Some include structures that date from prehistoric times, such as the stone buildings constructed by the ancient Anasazi civilization that appear in "day 7, Chaco Culture National Historic Park, New Mexico, 11:18" and "day 7, Chaco Culture National Historic Park, New Mexico, 11:19." Others are of architectural configurations built in the late-nineteenth century, such as the circular water reservoirs depicted in "day 19, near Barker Dam, Joshua Tree National Park, California, 34:8." The repetitions of these motifs reveal Cicetti's instinctive response as an architect to the area's varying forms that denote human activity and habitation.

Other motifs that recur in nearly half of the images of *Marking the Land 1* are fences, telephone or utility poles, and wires. These photographs characterize the various ways in which these rough hewn or manufactured objects of wood, wire, and metal have imposed vertical and horizontal patterns on the land. Because such geometry does not occur naturally in landscape, its patterns impose a sense of human measure on the vast and seemingly endless desert lands of scrubby

grasses, weeds, and shrubs. For example, in "day 1, route 104 towards Trementina, New Mexico, 2:27," the grid formed by the vertical and horizontal components of a utility pole and fence post links the land and sky and creates a pattern echoed in the land with the furrow that stretches diagonally beyond the pole to end abruptly along a line that parallels that of the distant horizon.

Or again, in "day 3, route 66 west, between Palomas and Montoya, New Mexico, 5:7," we view the vastness of the earth through a series of interlocking vertical and horizontal elements— gates, poles, and fence lines. With "day 9, Hubbell Trading Post National Historic Site, Arizona, 14:28," the grid of irregular and sometimes broken components of a wooden and wire fence dominates the composition and screens visual access to the landscape forms behind it. "Day 11, Homol'ovi Ruins State Park, Arizona, 20:8" and "day 16, route 66, Hualapai reservation, Arizona, 29:1" capture the rhythmic repetition of fence elements of varying sizes and shapes that either meander through the landscape in response to its natural undulations or impose the order of repeating rectangular shapes onto areas of flattened foreground. And, in "day 23, beach, Santa Monica State Park, California, 39:31," fencing stretches across the beach as a diagonal that veils and partially obscures the horizon line, which is delineated by the vertical repetitions of utility poles.

At the same time that Cicetti's photographs document the great variety of human-made structures that have marked the land of the American Southwest, her images never include people.

Yet, because humans have been responsible for imposing these structures on the land—whether as buildings, bridges, fences, railroad tracks, or roads—their presence in these hauntingly silent and arresting images is deeply felt, as is Cicetti's as photographer. Thus her work becomes a sequence of documented, personal moments through which the viewer can come to terms with the photographer's concept of place and the role humans have played over the centuries and always will play in marking places in the land and assigning them meaning.

Barbara Buhler Lynes

Curator, Georgia O'Keeffe Museum

The Emily Fisher Landau Director,

Georgia O'Keeffe Museum Research Center

Photographs

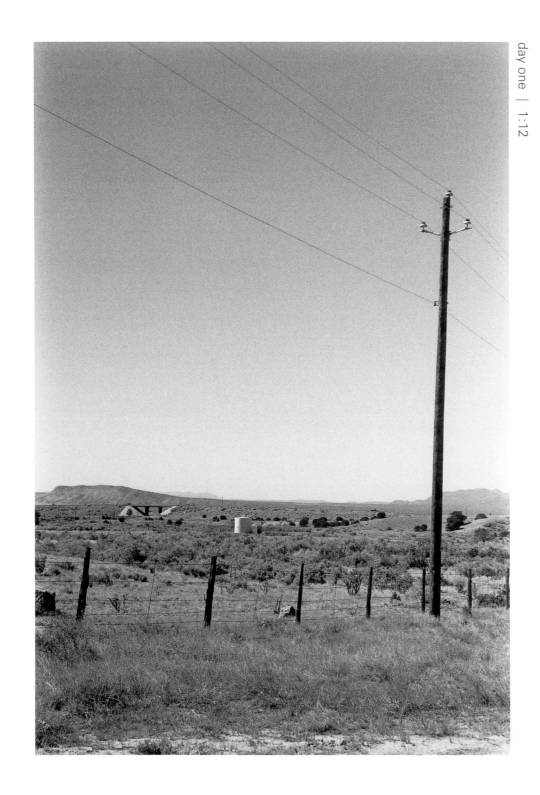

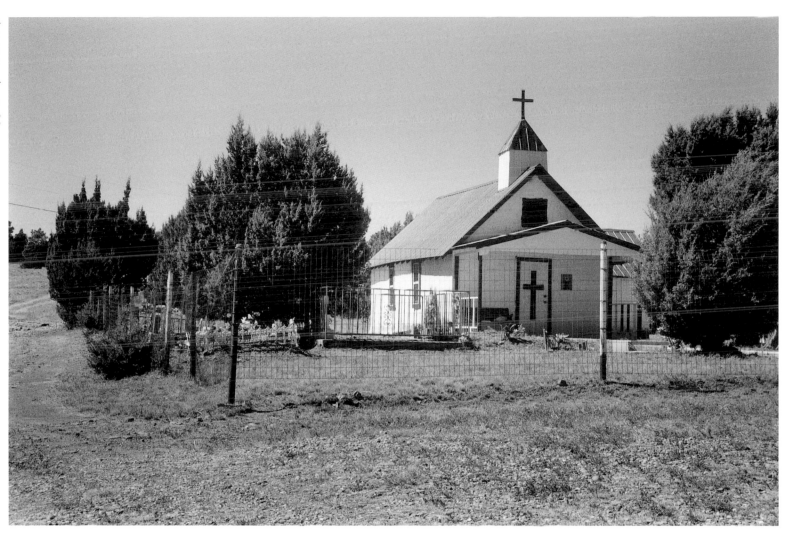

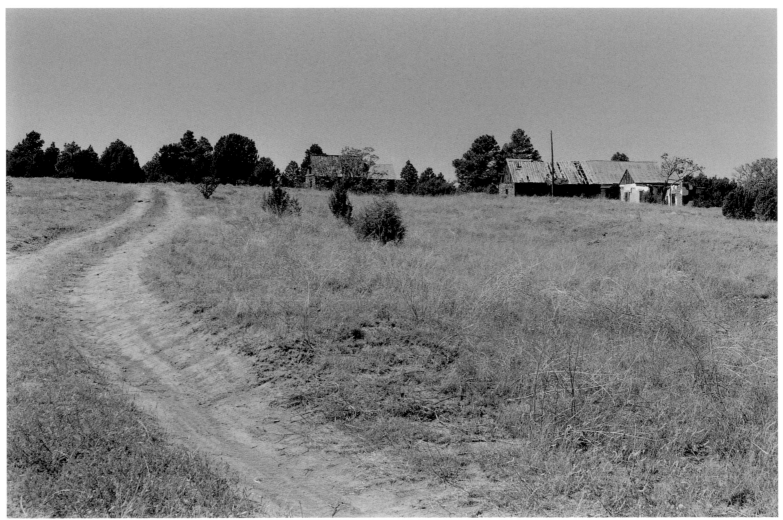

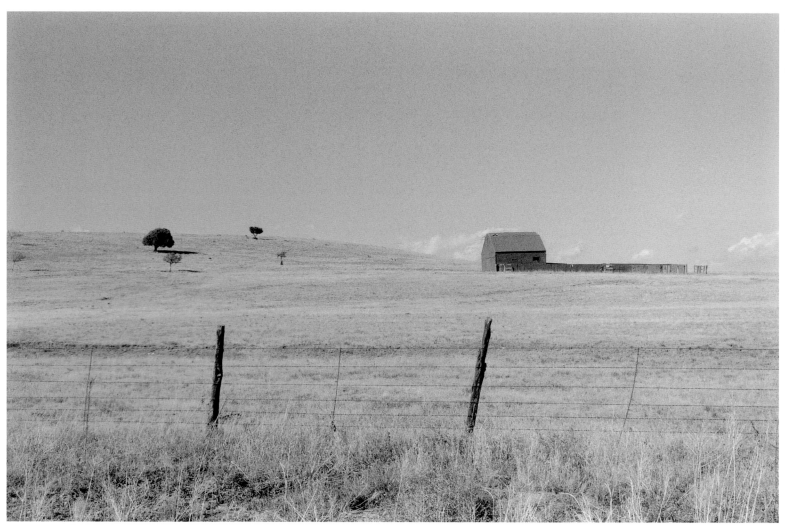

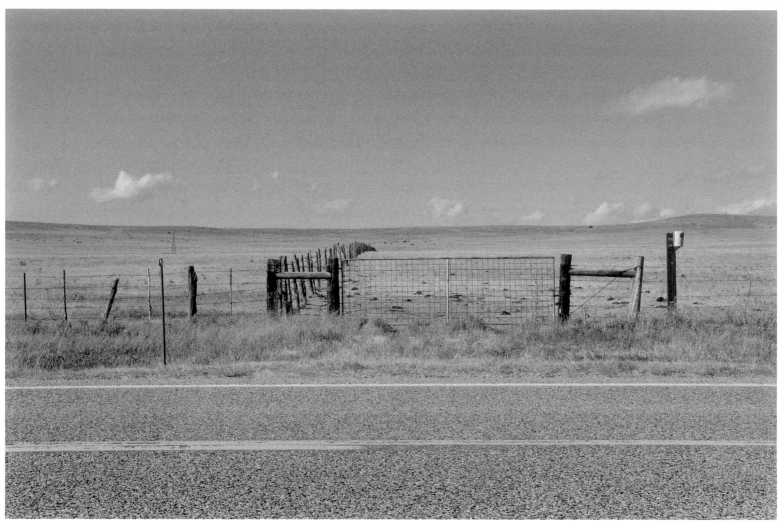

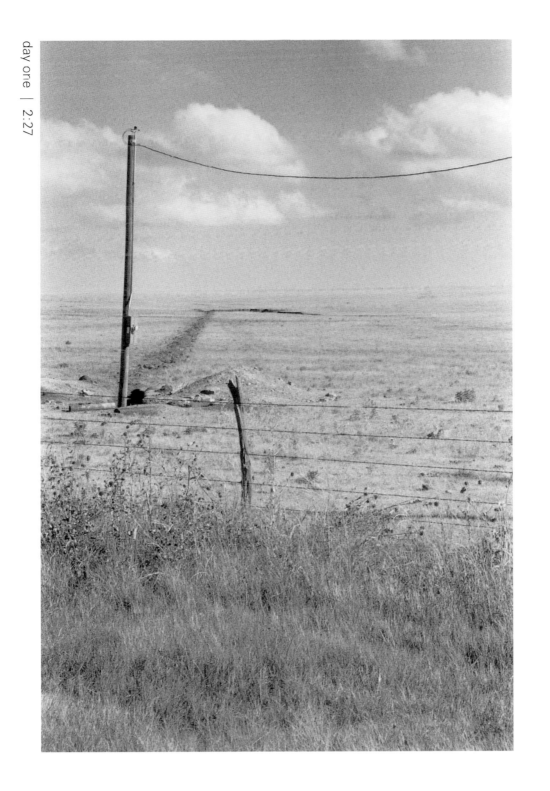

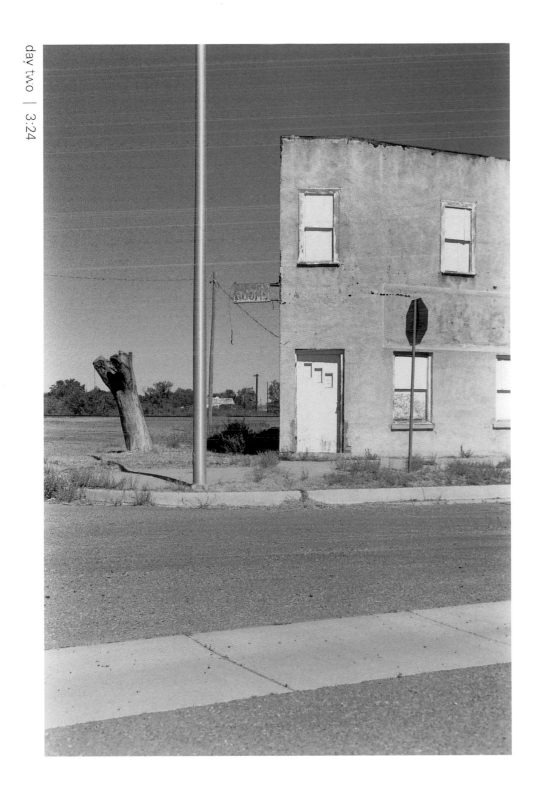

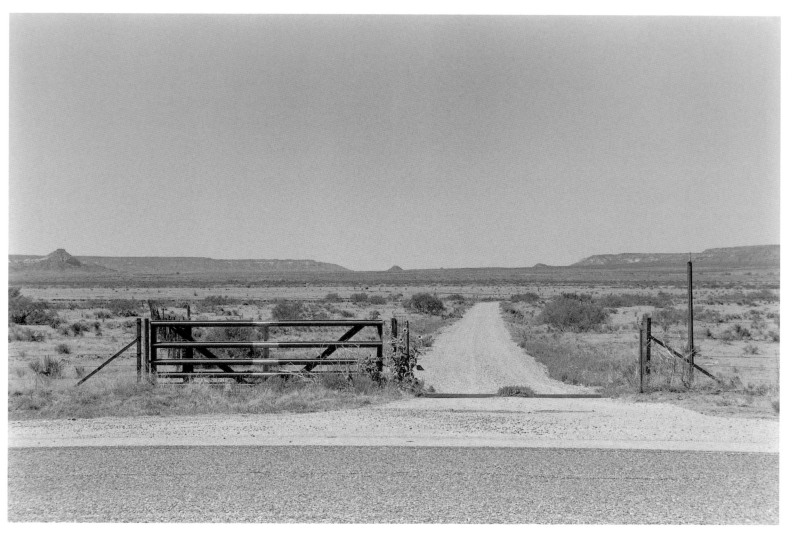

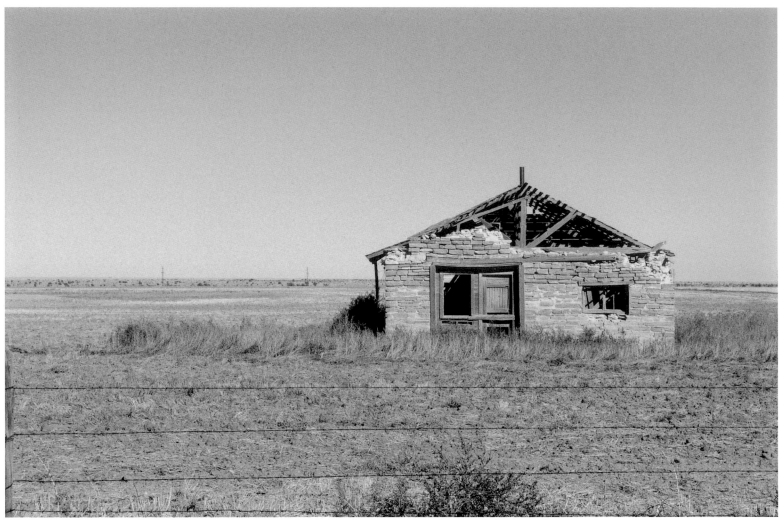

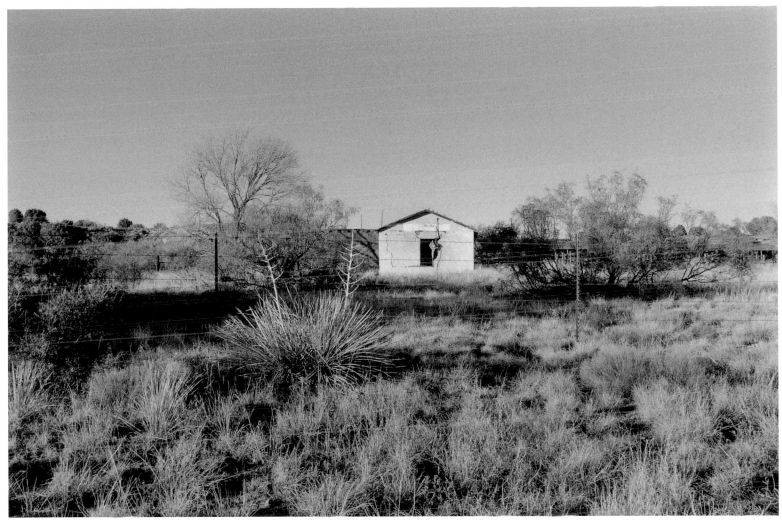

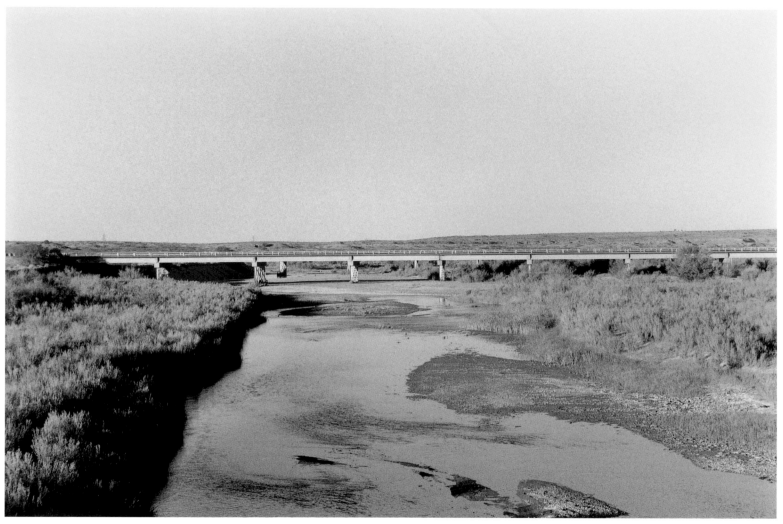

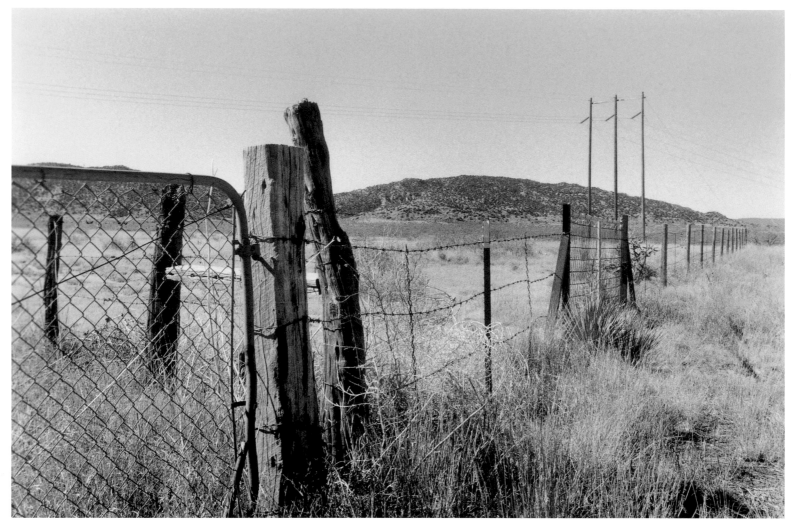

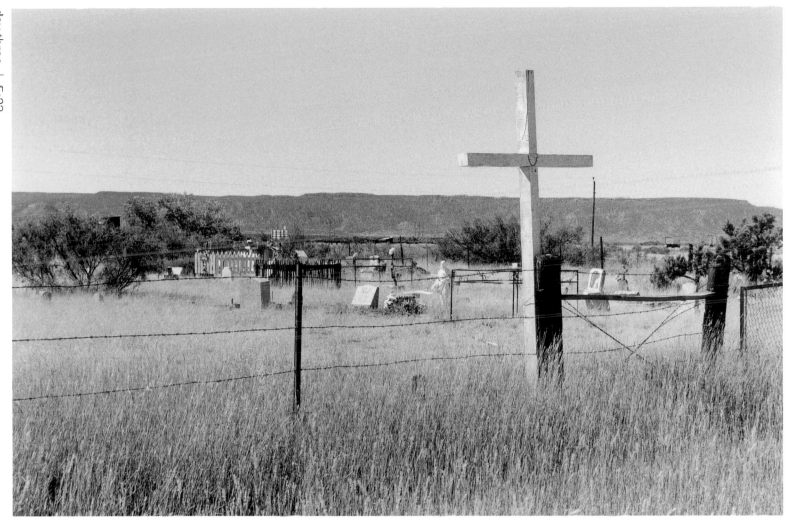

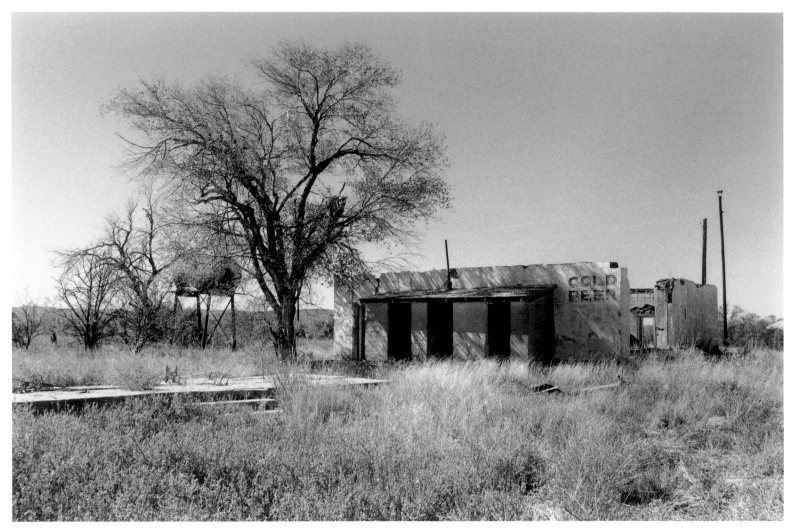

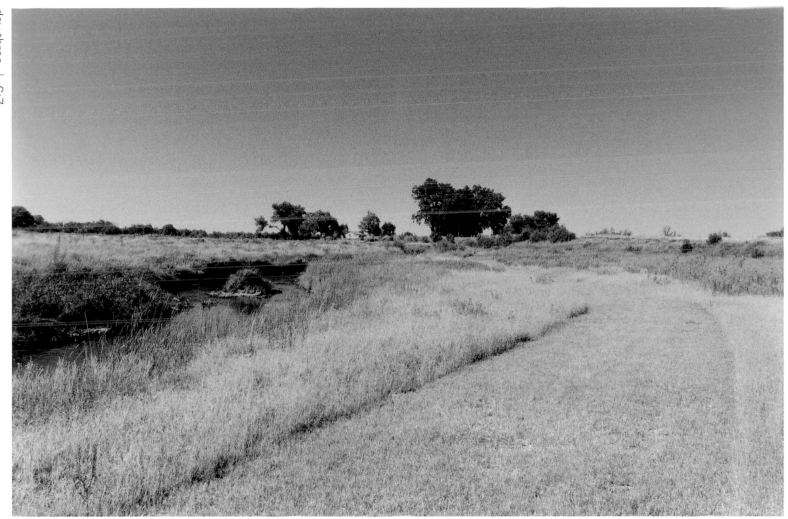

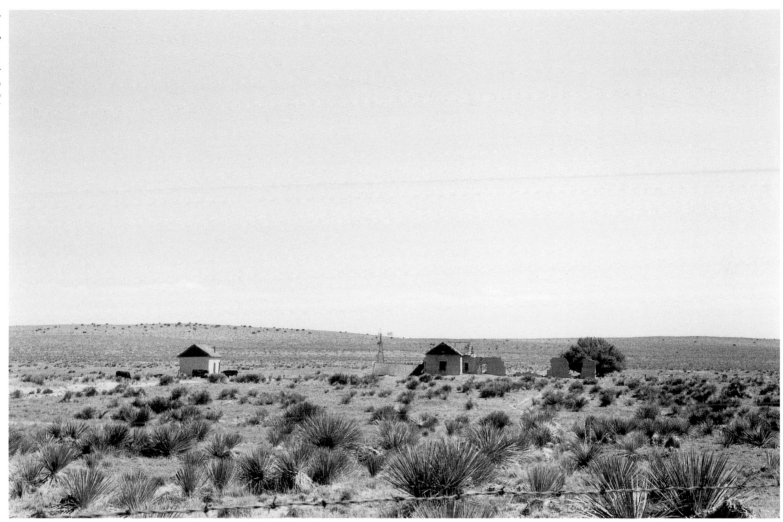

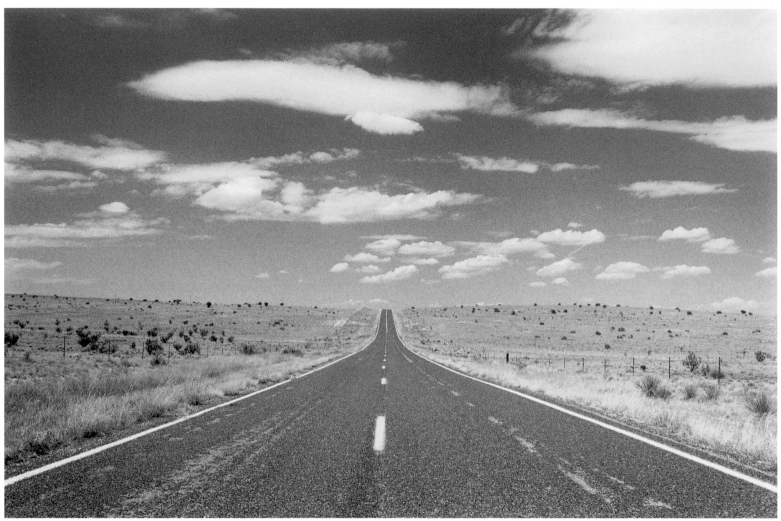

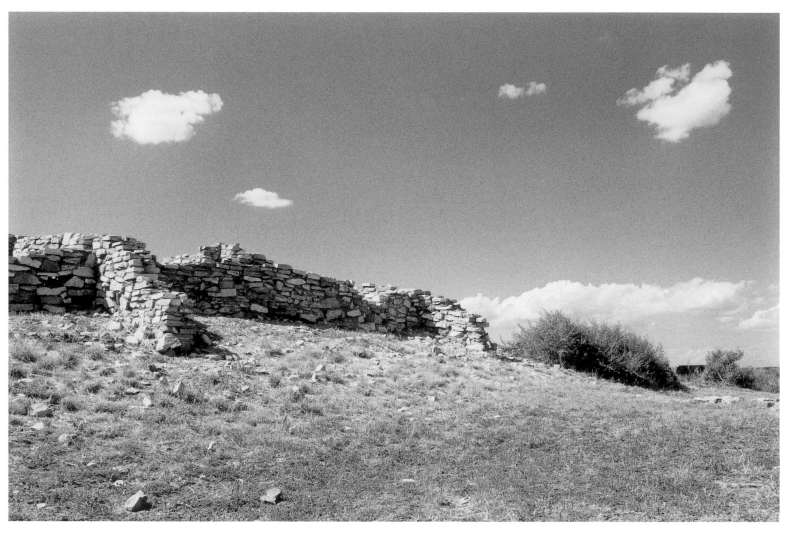

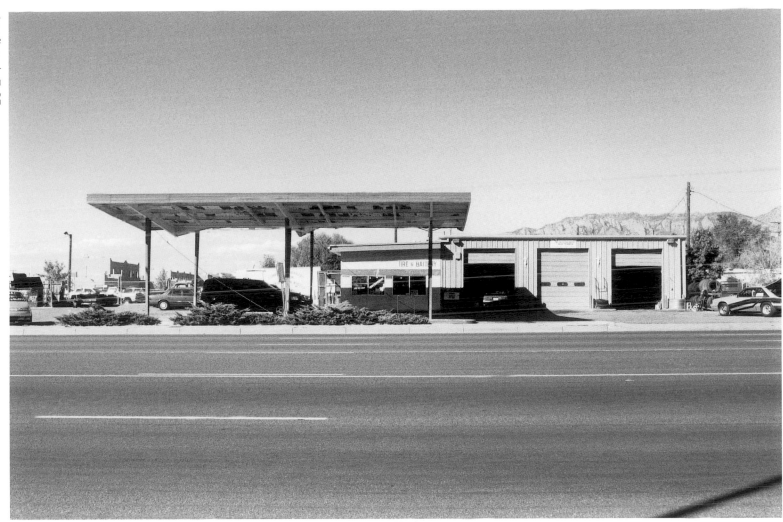

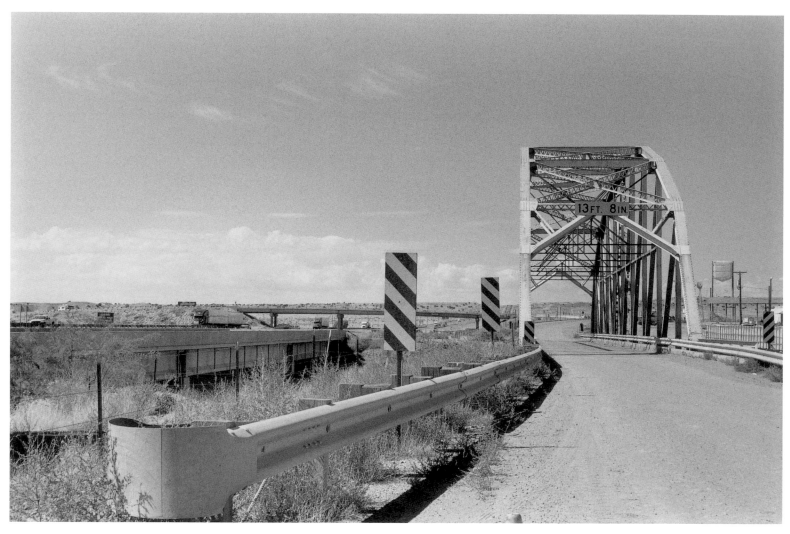

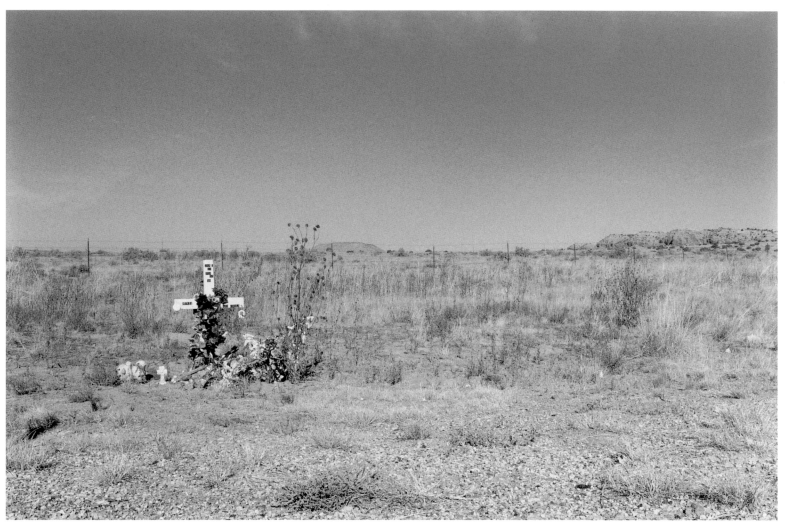

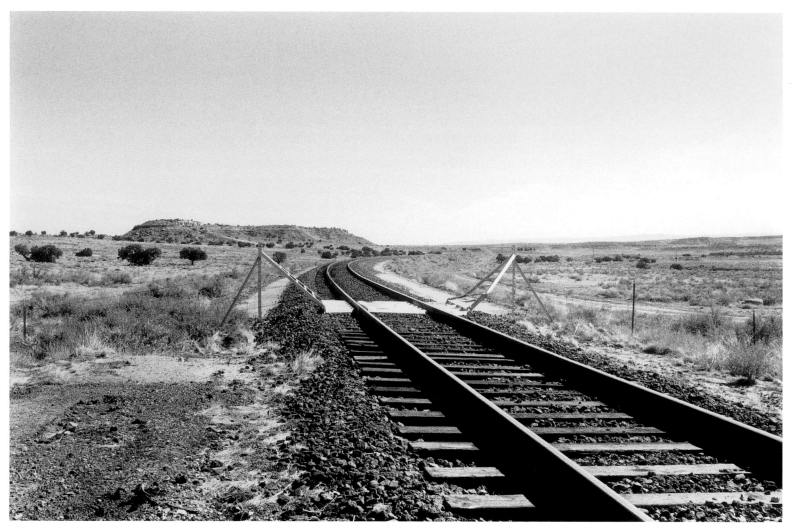

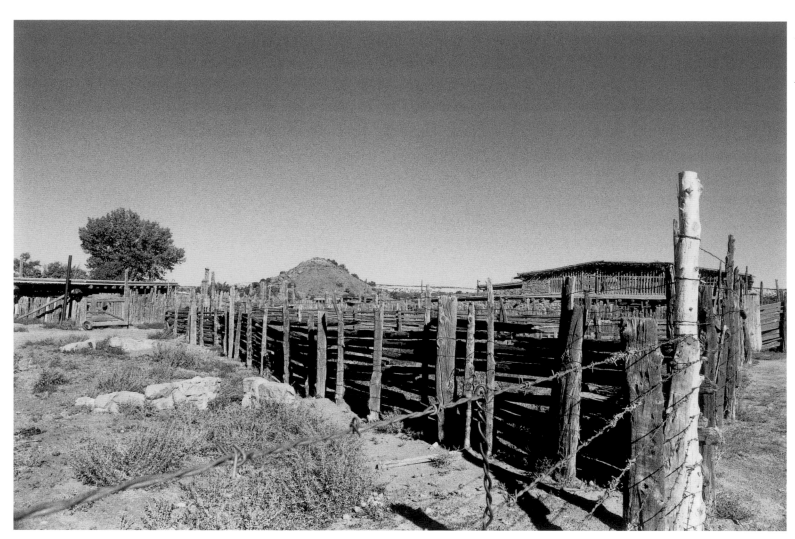

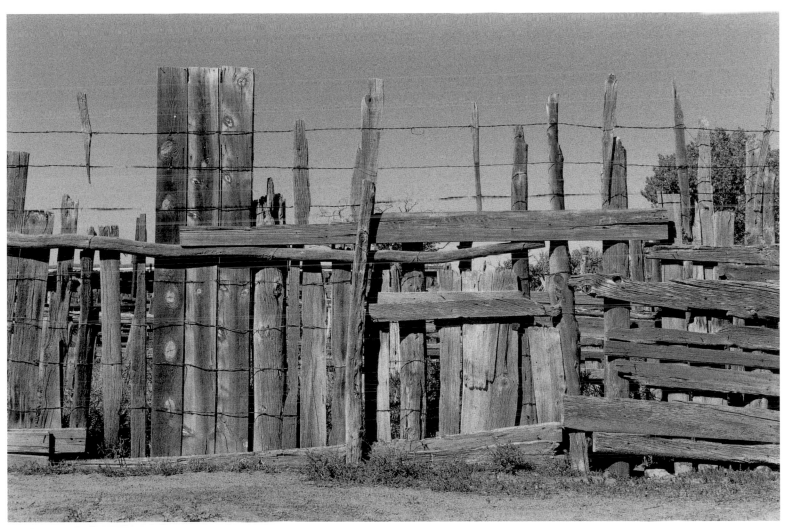

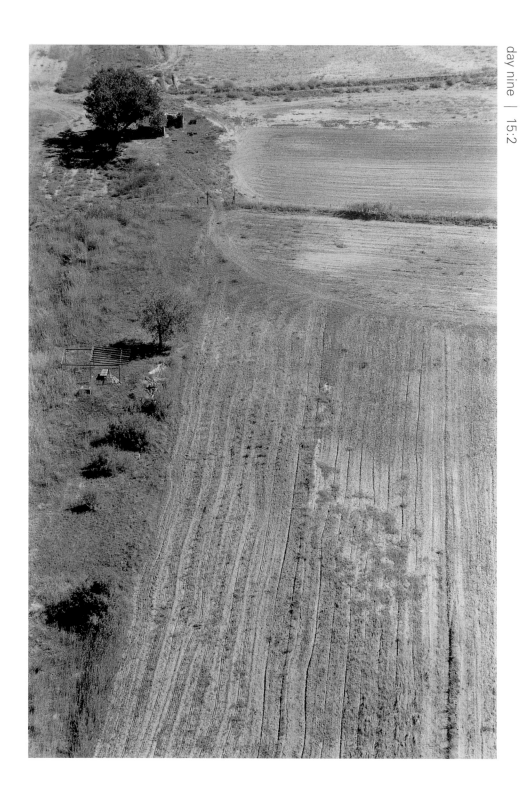

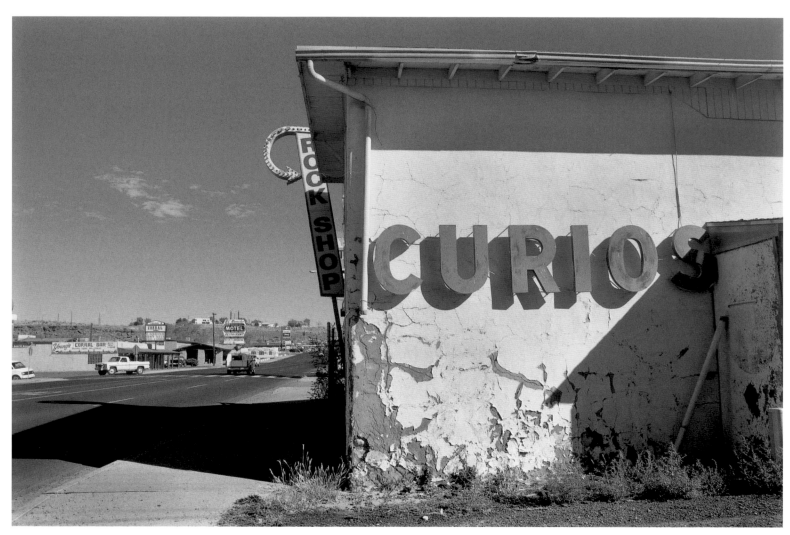

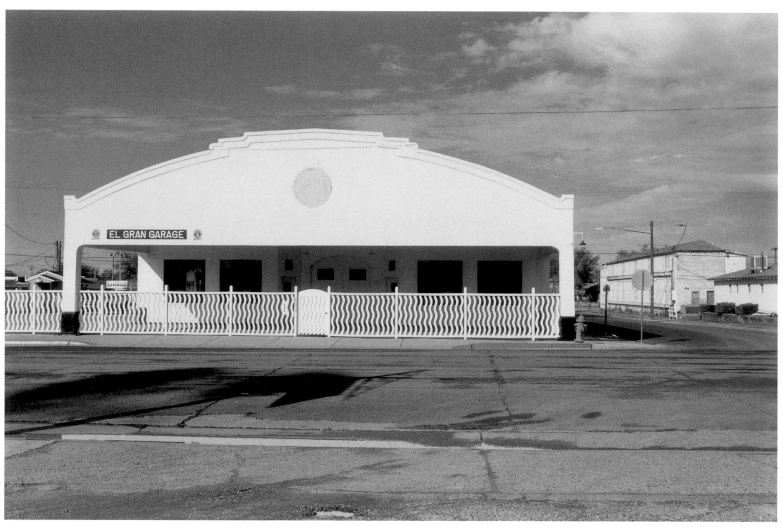

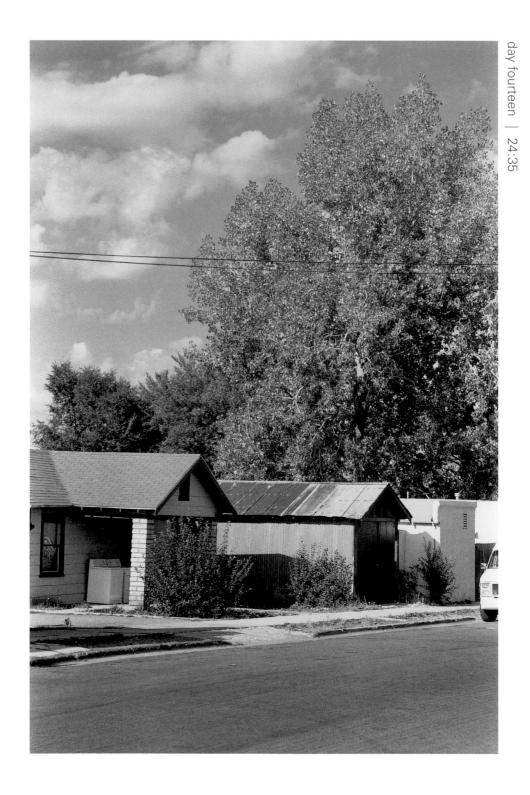

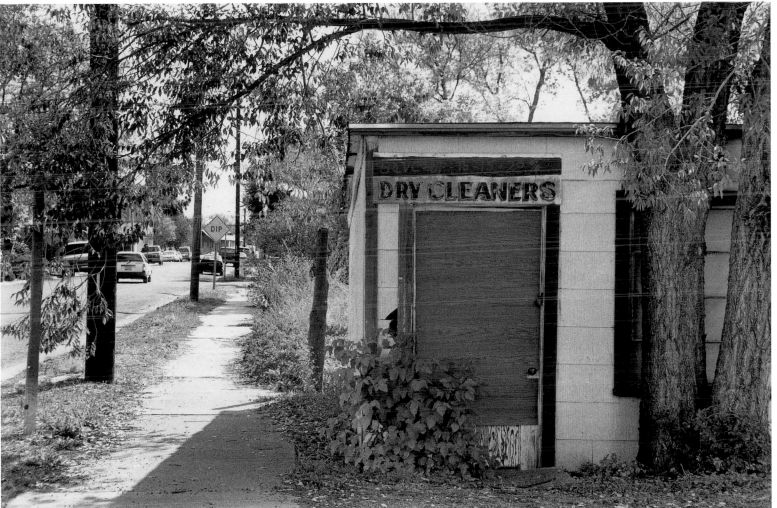

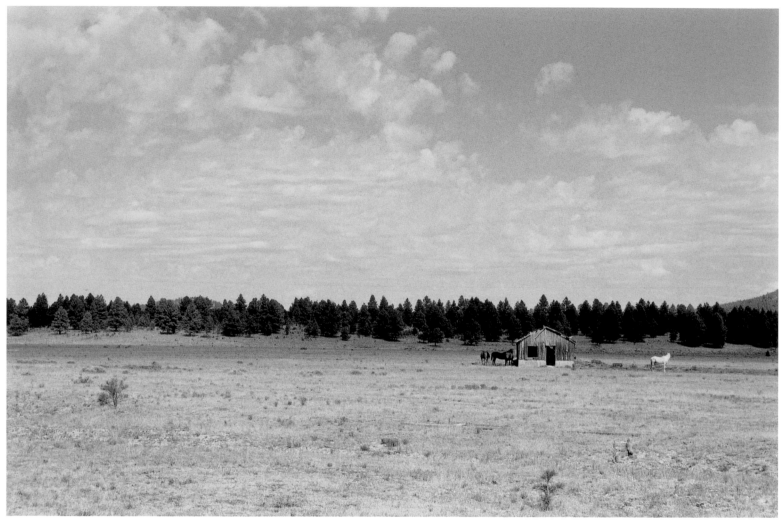

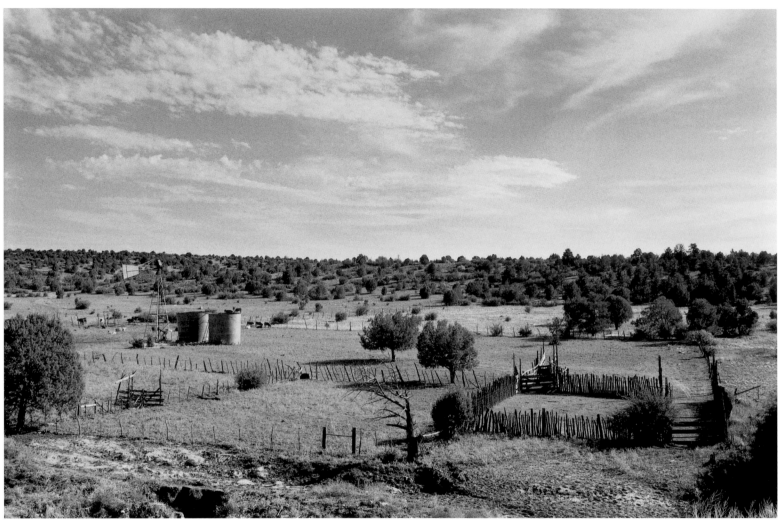

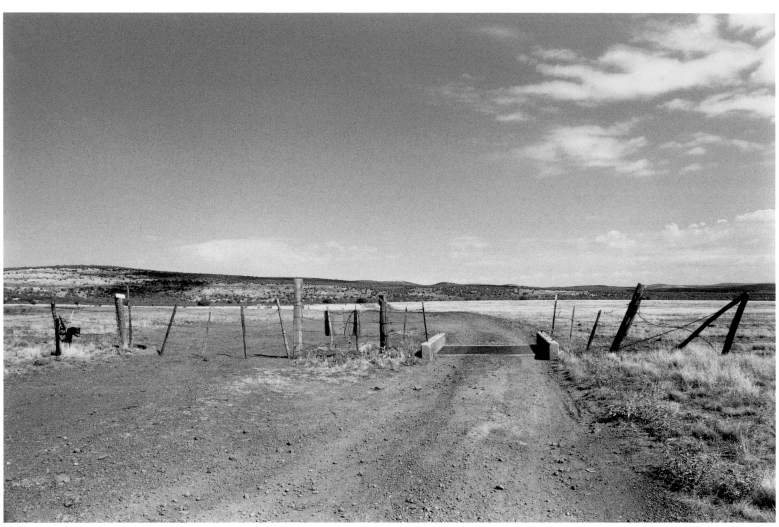

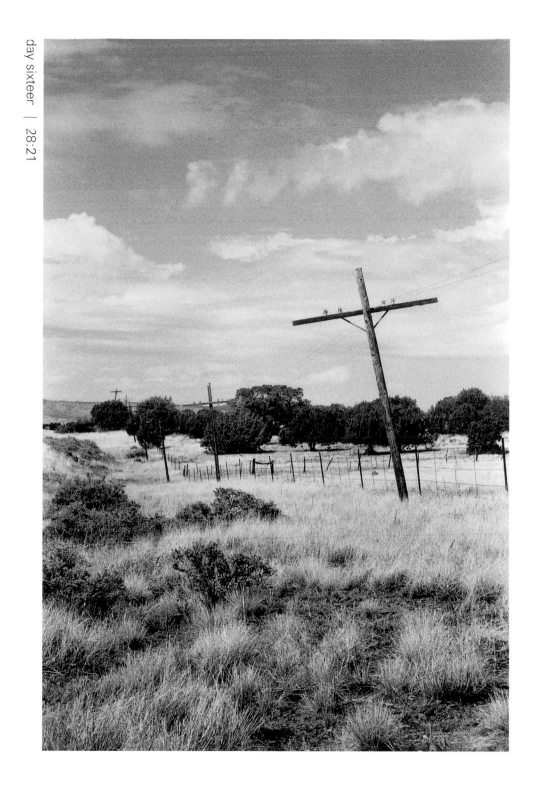

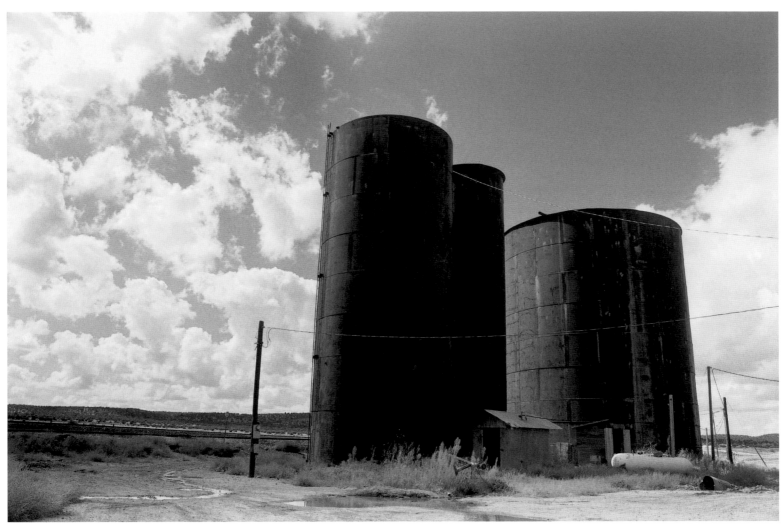

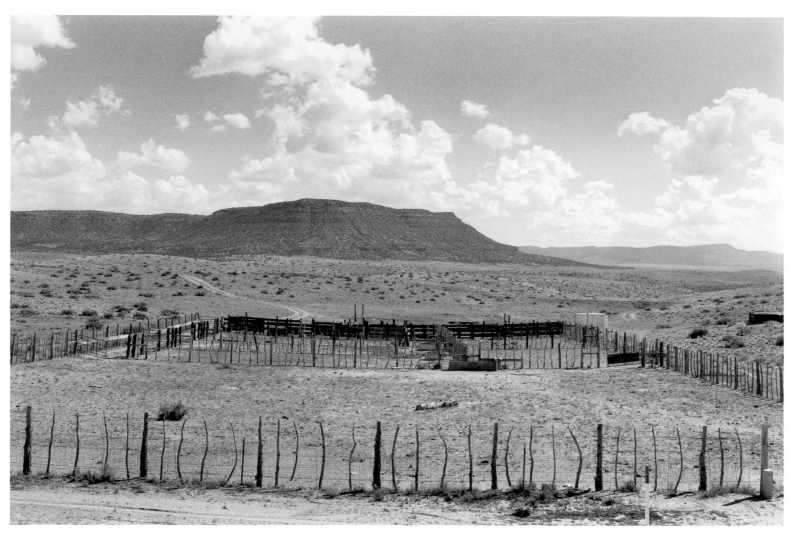

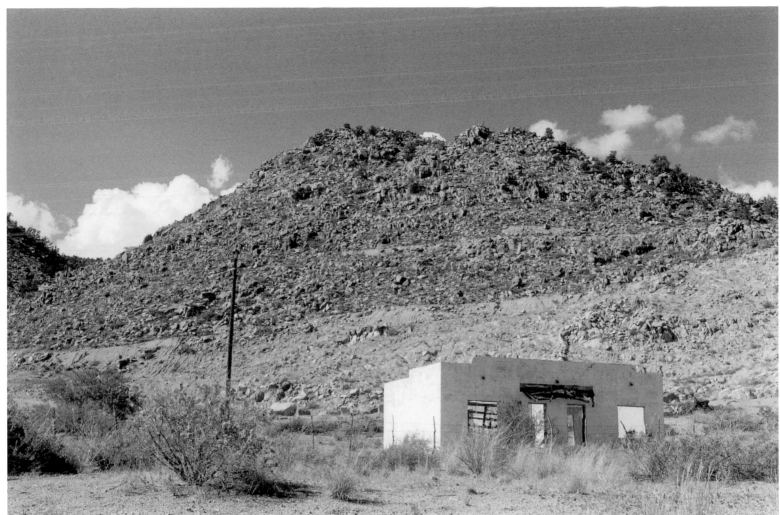

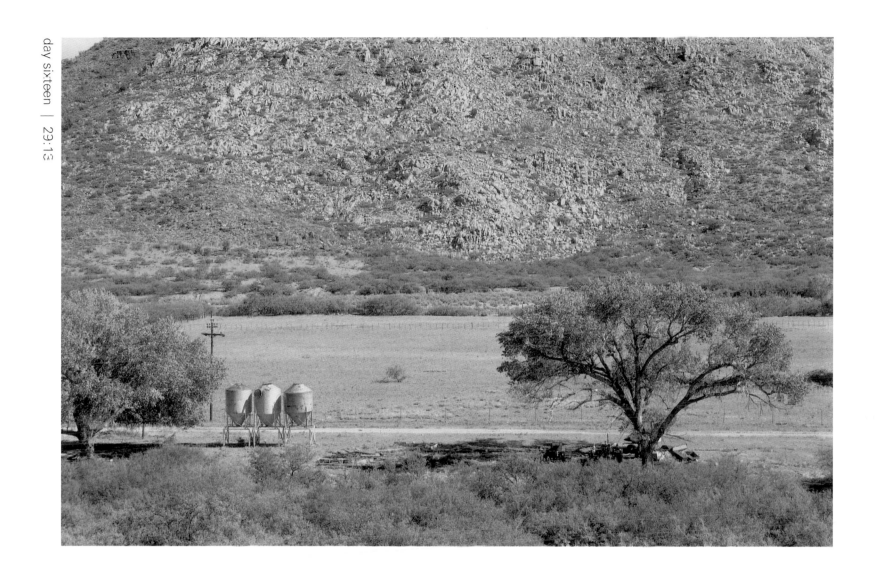

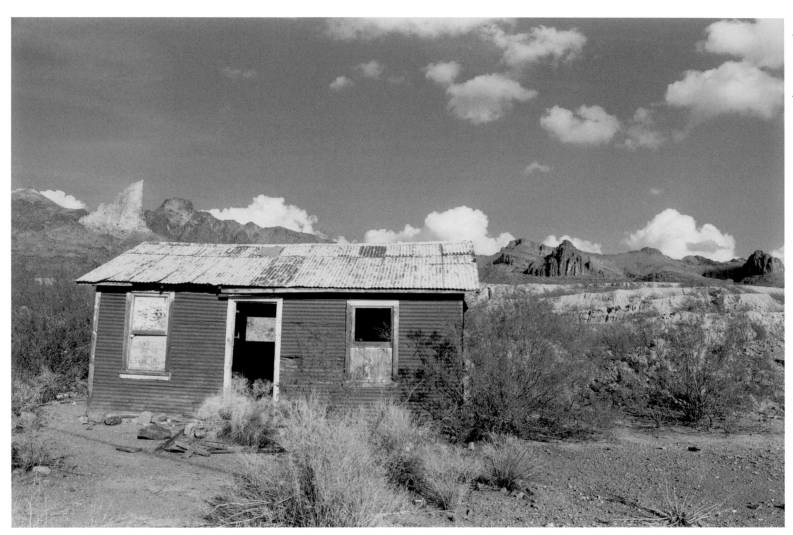

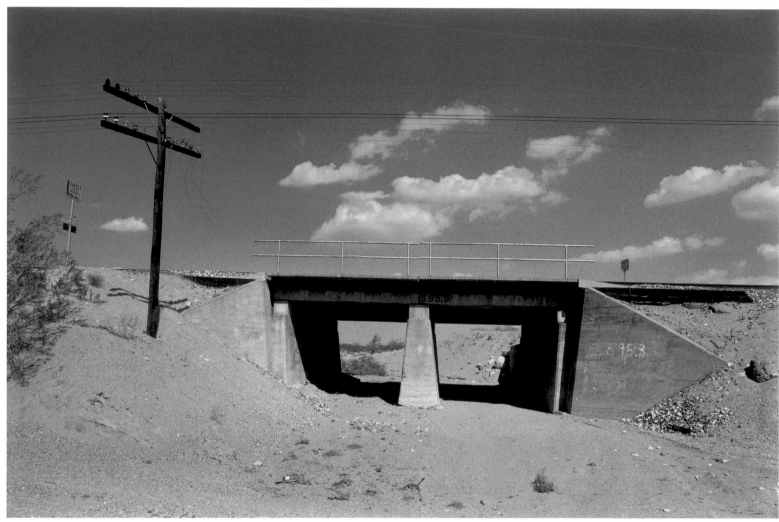

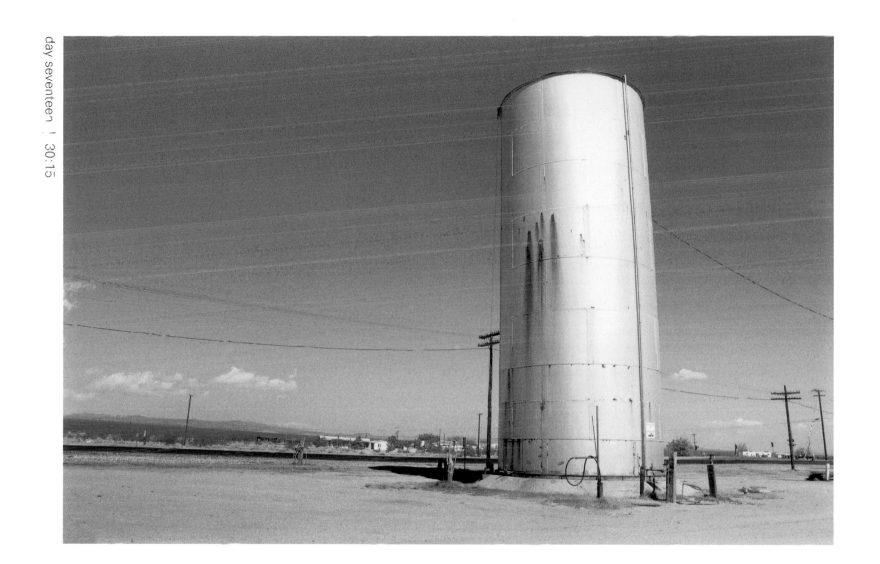

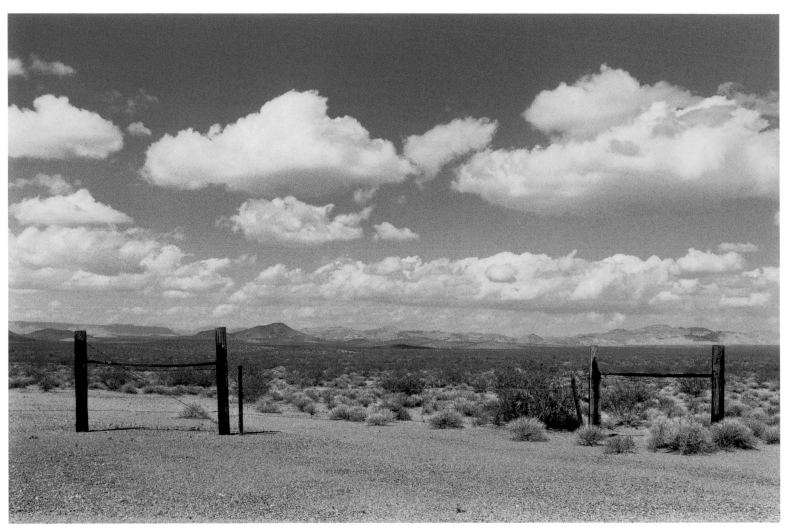

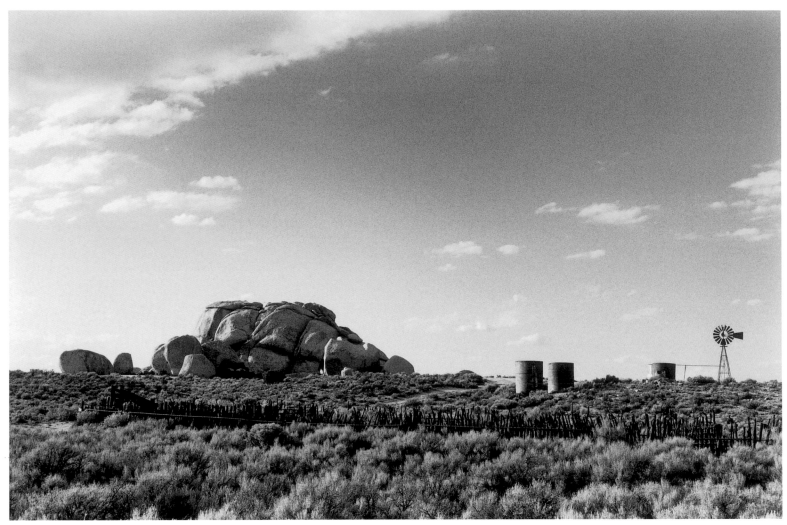

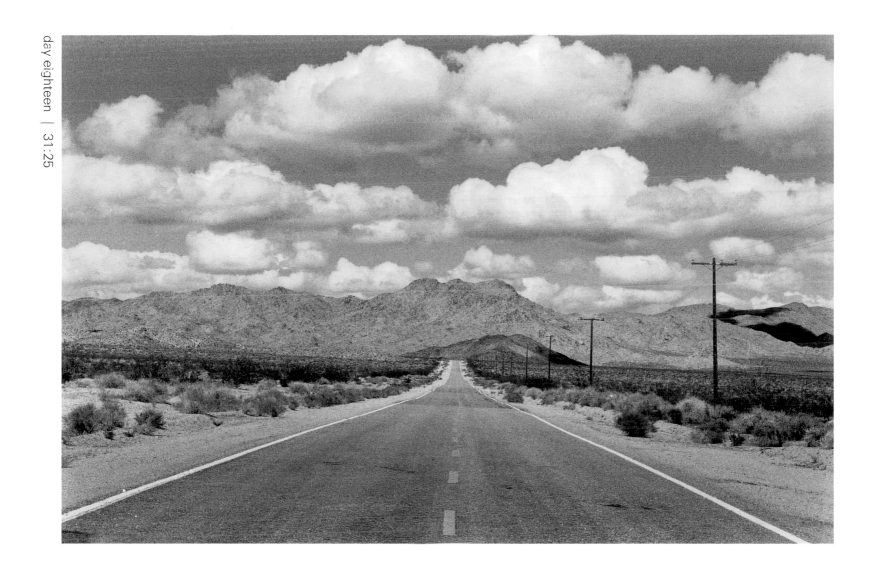

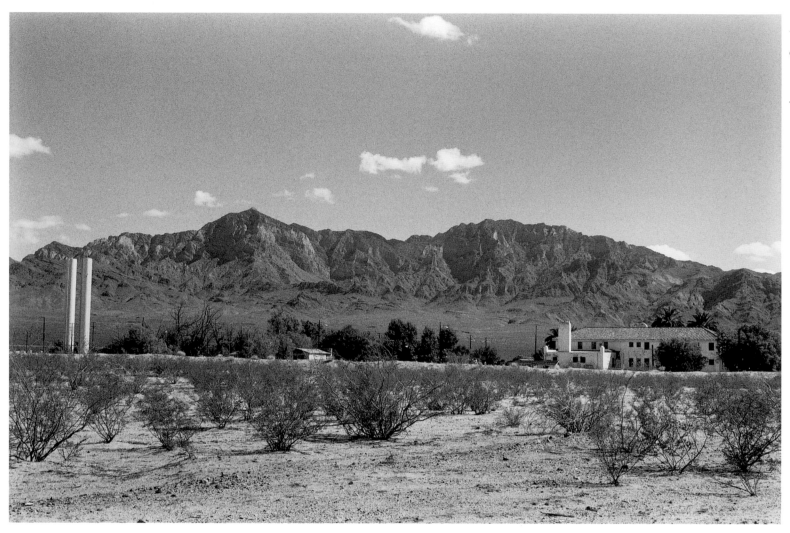

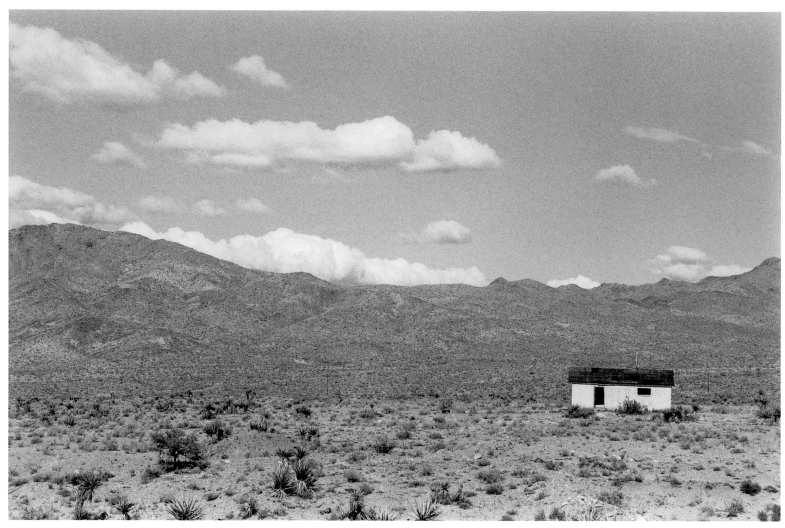

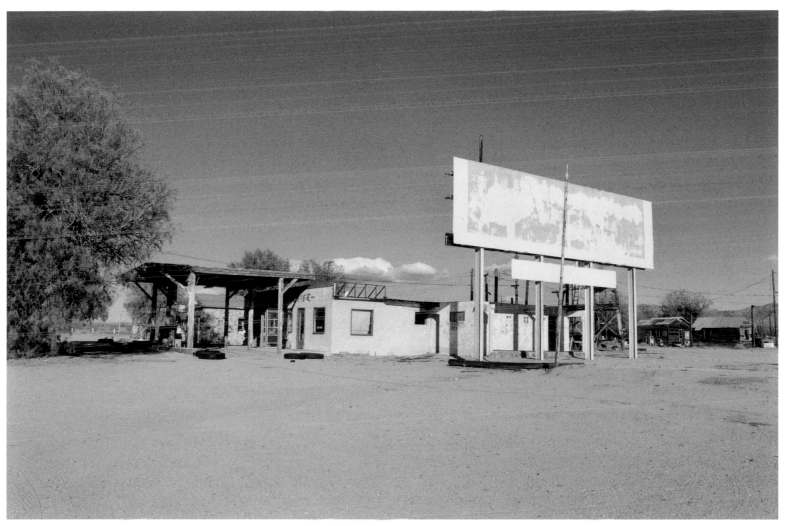

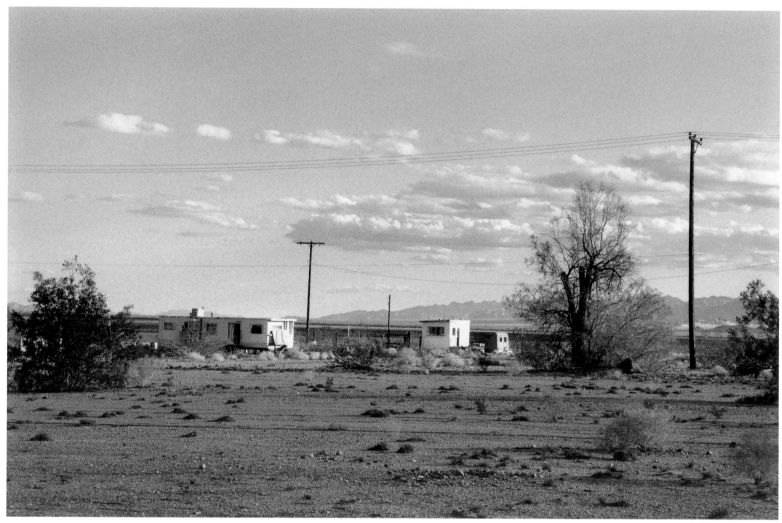

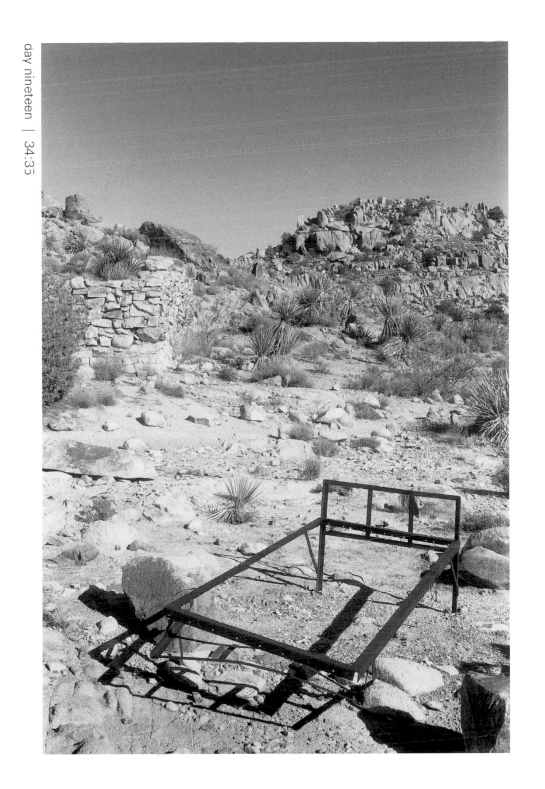

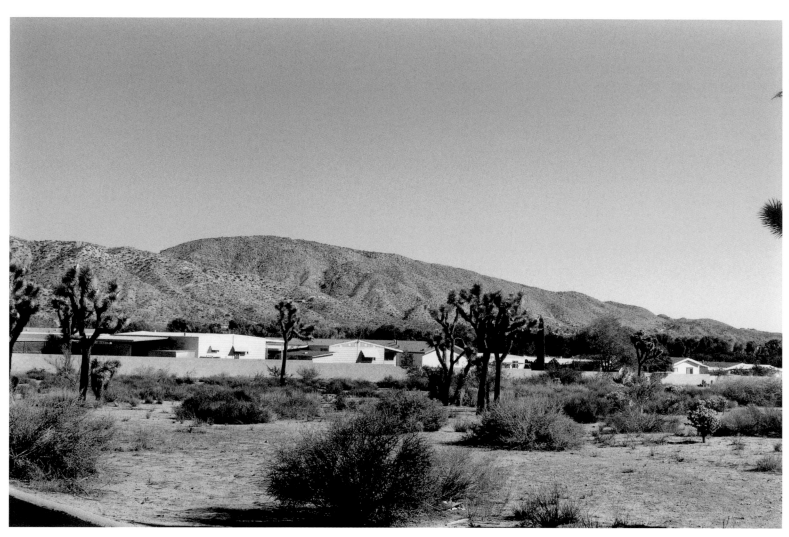

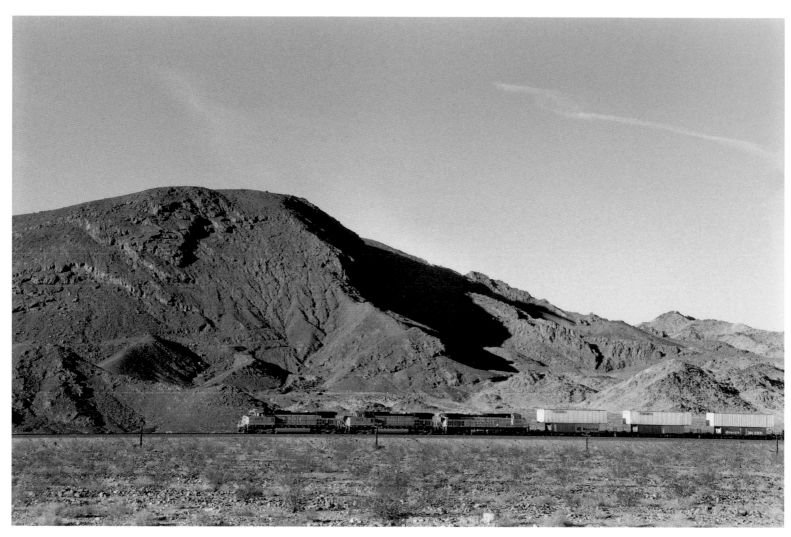

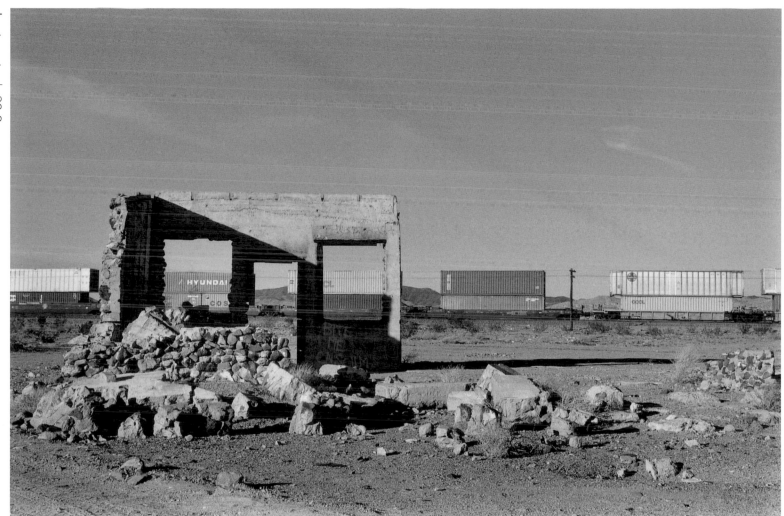

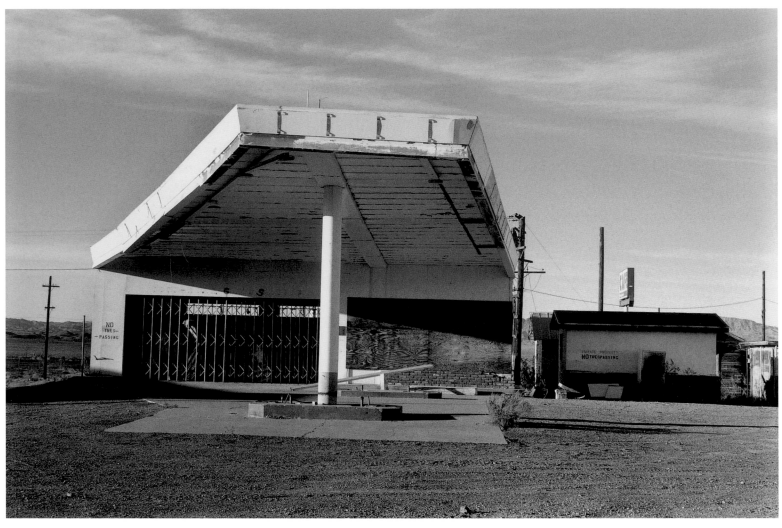

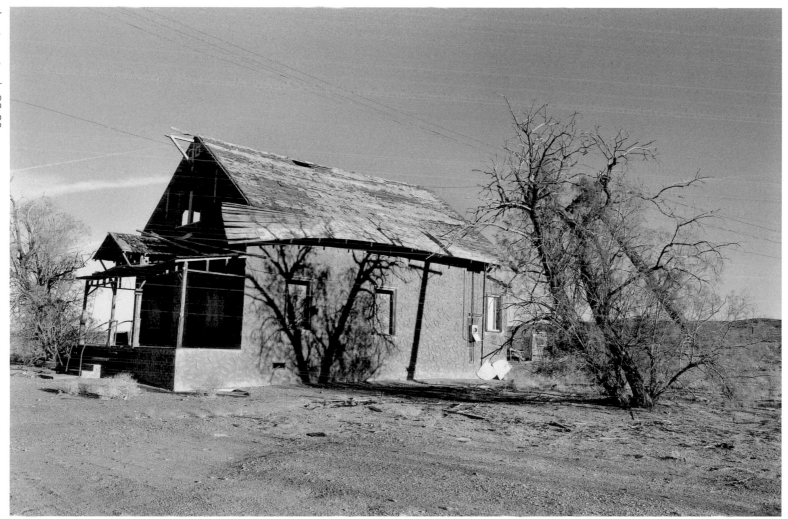

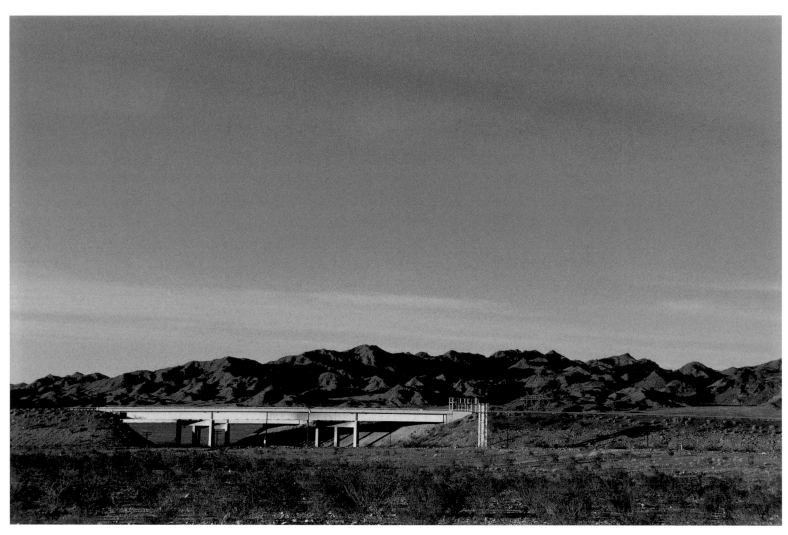

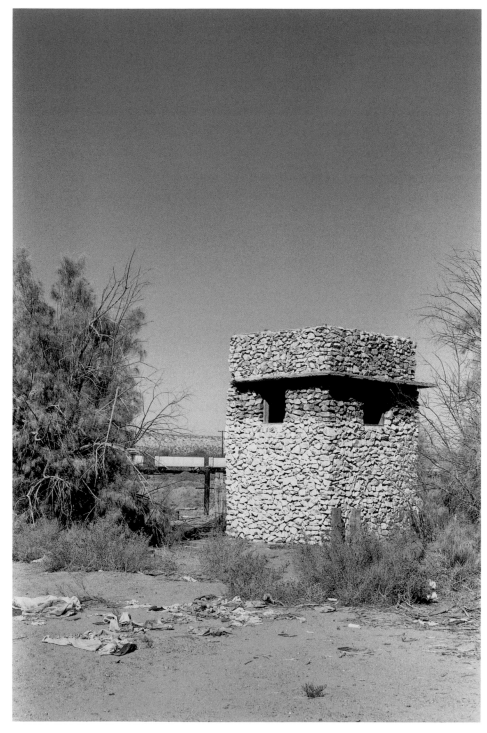

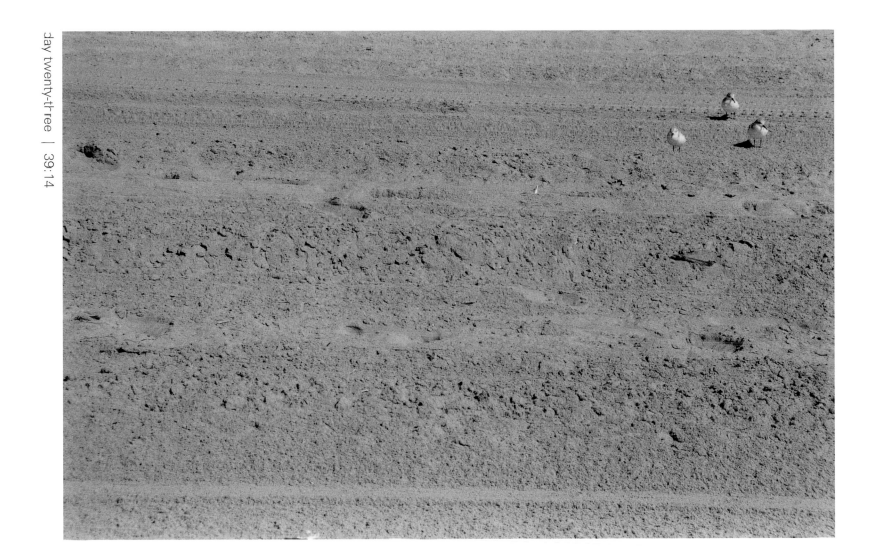

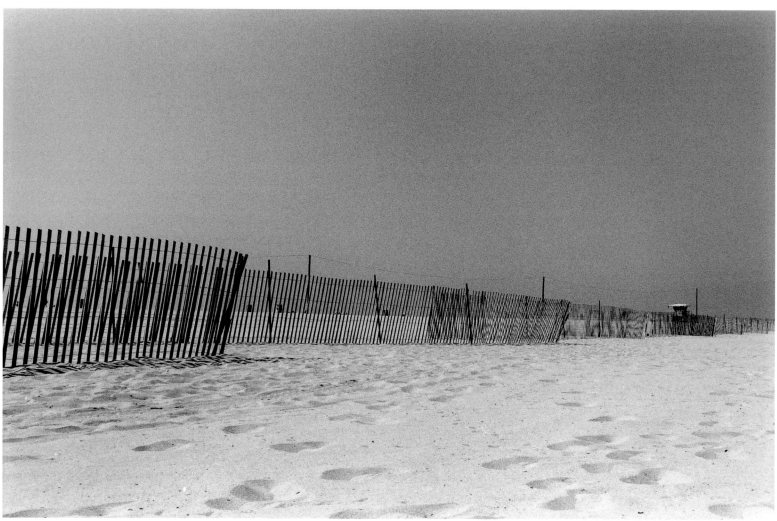

Polaroid Log

DAY THREE | 26 SEPTEMBER 2000

34 Route 66 at Palomas, New Mexico

35 Route 66 towards Montoya, New Mexico

36 Route 66 between Montoya and Newkirk, New Mexico

37 Route 66 between Montoya and Newkirk, New Mexico

38 Route 66 between Cuervo and Santa Rosa, New Mexico

39 Route 84 east towards Fort Sumner, New Mexico

40 Route 84 east towards Fort Sumner, New Mexico

41 Route 60 west towards Yeso, New Mexico

42 train at Yeso, New Mexico

43 train at Yeso, New Mexico

44 Route 285 north from Vaughn towards Clines Corners, New Mexico

DAY FOUR | 27 SEPTEMBER 2000

45 Route 66 Moriarty, New Mexico

46 Route 41 south near McIntosh, New Mexico

47 Route 41 south near Estancia, New Mexico

48 Route 41 south from Willard, New Mexico

49 Route 42 south towards Cedarvale, New Mexico

50 Route 54 south of Corona, New Mexico

51 Route 55 north to Gran Quivira, New Mexico

52 Route 55 north to Gran Quivira, New Mexico

53 Route 55 north towards Mountainair, New Mexico

54 Route 55 north towards Estancia, New Mexico

55 Route 66 west, Moriarty, New Mexico

56 Route 66 west, near Edgewood, New Mexico

57 Route 66 west, near Edgewood, New Mexico

58 Route 66 west, near Carnuel, New Mexico

DAY FIVE | 28 SEPTEMBER 2000

59 Route 66 east, between Juan Tabo and Tramway, Albuquerque, New Mexico

60 Route 66 east, near Juan Tabo, Albuquerque, New Mexico

61 Route 66 east, between Eubank and Juan Tabo, Albuquerque, New Mexico

62 Route 66 east near Eubank, Albuquerque, New Mexico

63 Route 66 east near Wyoming, Albuquerque, New Mexico

64 Route 66 east near Louisiana, Albuquerque, New Mexico

65 Route 66 east near San Mateo, Albuquerque, New Mexico

66 Route 66 east near Madison, Albuquerque, New Mexico

67 Route 66 east, Nob Hill, Albuquerque, New Mexico

68 Route 66 east near Amherst, Albuquerque, New Mexico

69 Route 66 east near Cornell, Albuquerque, New Mexico

70 Route 66 east near Sycamore, Albuquerque, New Mexico

71 Route 66 east railroad trestle, near 1st Street, Albuquerque, New Mexico

72 Route 66 east near 5th Street, Albuquerque, New Mexico

73 Route 66 east near 8th Street, Albuquerque, New Mexico

74 Route 66 east near 10th Street, Albuquerque, New Mexico

75 Route 66 east near San Pasquale, Albuquerque, New Mexico

76 Route 66 west near San Pasquale, Albuquerque, New Mexico

77 Route 66 east near Rio Grande, Albuquerque, New Mexico

DAY SIXTEEN | 9 OCTOBER 2000

191 I-40 west near Ash Fork, Arizona

192 Route 66 west Ash Fork, Arizona

193 Route 66 west Ash Fork, Arizona

194 I-40 west between Ash Fork and Pinaveta, Arizona

195 Route 66 west Pinaveta, Arizona

196 Route 66 west between Pinaveta and Seligman, Arizona

197 Route 66 west towards Seligman, Arizona

198 Route 66 west Seligman, Arizona

199 Route 66 west after Seligman, Arizona

200 Route 66 west Grand Canyon Caverns, Arizona

201 Route 66 west Truxton, Arizona

202 Route 66 west Hackberry, Arizona

203 Route 66 west Kingman, Arizona

204 Route 66 west Kingman, Arizona

205 Route 66 west Kingman, Arizona

206 Route 66 west Mohave County, Arizona

207 Route 66 west Golden Shores, Arizona

DAY SEVENTEEN | 10 OCTOBER 2000

208 Route 66 west Needles, California

209 Route 66 west Needles, California

210 I-40 west of Needles, California

211 I-40 west of Needles, California

212 Route 66 west towards Goffs, California

213 Route 66 west towards Goffs, California

214 Route 66 west Fenner, California

215 Route 66 west Essex, California

216 Essex Road north, Mojave National Preserve, California

217 Essex Road north, Mojave National Preserve, California

218 Wild Horse Canyon Road, Mojave National Preserve, California

219 Kelbaker Road, Mojave National Preserve, California

220 Kelbaker Road, Mojave National Preserve, California

DAY EIGHTEEN | 11 OCTOBER 2000

221 Kelso - Cima Road, Mojave National Preserve, California

222 Morning Star Mine Road, Mojave National Preserve, California

223 Lanfair Road, Mojave National Preserve, California

224 Route 66 west near Fenner, California

225 Route 66 west past Essex, California

226 Route 66 west past Essex, California

227 Amboy Road south, California

DAY TWENTY-TWO 15 OCTOBER 2000

267 Route 66 west near Wilton, Los Angeles, California

268 Route 66 west near Vine, Hollywood, California

269 Route 66 west near Formosa, Hollywood, California

270 Route 66 west near Curson, Hollywood, California

271 Route 66 west near Westbourne, West Hollywood, California

272 Route 66 west near Rodeo, Beverly Hills, California

273 Route 66 west near Beverly, Beverly Hills, California

274 end of Route 66 at Ocean Avenue, Santa Monica, California

DAY TWENTY-THREE | 16 OCTOBER 2000

Photo Log

day one | 1:12 Route 285 south towards Lamy, New Mexico

day one | 1:30 between Tecolote and Las Vegas, New Mexico

day one | 1:32 between Tecolote and Las Vegas, New Mexico

day one | 2:14 adjacent to rail yards, Las Vegas, New Mexico

day one | 2:20 Route 104, east of Las Vegas, New Mexico

day one | 2:23 Route 104, east of Las Vegas, New Mexico

day one | 2:25 Route 104 towards Trujillo, New Mexico

day one | 2:27 Route 104 towards Trementina, New Mexico

day one | 2:31 Route 104, towards Trementina, New Mexico

day two | 3:24 adjacent to rail yards, Tucumcari, New Mexico

day two | 3:26 Route 209 south, towards Quay, New Mexico

day two | 3:30 Route 252 south, towards McAlister, New Mexico

day two | 4:21 Route 469 north, between Grady and San Jon, New Mexico

day two | 4:29 Route 66 west, between San Jon and Tucumcari, New Mexico

day two | 4:32 I-40 bridge east of Tucumcari, New Mexico

day two | 4:35 Route 66 east of Tucumcari, New Mexico

day three | 5:7 Route 66 west, between Palomas and Montoya, New Mexico

day three | 5:23 Route 66, cemetery at Montoya, New Mexico

day three | 5:27 Route 66, Montoya, New Mexico

day three | 6:7 Bosque Redondo, Fort Sumner, New Mexico

day four | 6:22 Route 41 south, towards Estancia, New Mexico

day four | 6:31 Route 42 south, towards Cedarvale, New Mexico

day four | 6:34 Route 55 north, towards Claunch, New Mexico

day four | 7:3 Route 55 north, Claunch, New Mexico

day four | 7:11 Gran Quivira, Salinas Pueblo Missions National Monument, New Mexico

day five | 7:35 Route 66 west, Albuquerque, New Mexico

day six | 8:23 I-40 west frontage road Rio Puerco bridge, New Mexico

day six | 9:17 El Malpais National Monument, New Mexico

day seven | 10:7 Route 605 north, New Mexico

day seven | 10:11 Route 509 north, New Mexico

day seven | 10:21 Route 509 north, New Mexico

day seven | 10:24 county road to Chaco Canyon, New Mexico

day seven | 11:18 Chaco Culture National Historic Park, New Mexico

day seven | 11:19 Chaco Culture National Historic Park, New Mexico

day nine | 14:26 Hubbell Trading Post National Historic Site, Arizona

day nine | 14:28 Hubbell Trading Post National Historic Site, Arizona

day nine | 15:2 Canyon de Chelly National Monument, Arizona

day nine | 17:13 Canyon de Chelly National Monument, Arizona

day ten | 17:32 Route 66, Holbrook, Arizona

day eleven | 20:8 Homol'ovi Ruins State Park, Arizona

day eleven | 20:24 Winslow, Arizona

day eleven | 20:36 road to Meteor Crater, Arizona

day twelve | 21:32 Sunset Crater Volcano National Monument, Arizona

day twelve | 22:27 Painted Desert, Arizona

day fourteen | 24:35 Flagstaff, Arizona

day fourteen | 25:9 Flagstaff, Arizona

day fourteen | 25:23 Route 66, near Parks, Arizona

day fourteen | 25:26 Williams, Arizona

day fourteen | 26:22 Route 89 south, Arizona

Afterword

(afterward)

In my education and career as an architect,
I have constantly questioned the meaning of place. As a student, I began using the camera as a
tool to help me see relationships between manufactured and natural forms, which I would have
otherwise unconsciously missed if it hadn't been for the anonymity of the lens. As I embarked on
my professional career, the camera was set aside for the computer. I eventually realized, through
my dissatisfaction with the process of professional architectural practice, that the camera had been
for me a vital extension of my thought processes. It was necessary to the conceptual dimensions
of my work. The predominance of the computer in practice had effectively disconnected me from
my personal process of discovery and growth.

Determined to expand my role as a creative professional, I received a travel grant in the
fall of 2000 to document, through photography, "the forms, materials, and methods of human
occupation along Route 66 in relation to the landscape." In the grant proposal, I was not entirely

clear about my underlying objectives. I knew I could spend countless moments silently considering a derelict barn set against an endless horizon, but what it meant for me as a physical or metaphysical experience was ill-defined. What I was clear about, however, was my desire to re-evaluate the acts of thinking and making through dialogue with the world around me via the camera.

During my three thousand-mile journey through New Mexico, Arizona, and California, I instinctively chose to capture the ways in which humankind over time has chosen to access, occupy, and transform a terrain as vast, scaleless, and timeless as that of the Southwest. I deliberately excluded the mark-makers from the photographs, to avoid having person as object. Human absence would instead be *felt* as a presence—as the resonant dialogue between built and natural form.

Back home in New York City, I poured over the contact sheets and became ever more intrigued with our relationship to the land we occupy and with how we dwell upon it. As demonstrated in the framing and content of the photographs themselves, I do not view nature simply as evidence of the transcendent divine. Instead, I perceive nature as a medium through which we may gain an understanding of self and approach the land from the standpoint of where and how "I" (humankind) may occupy space. Our marks upon the land help reveal and define our relationship to the earth—the thing that grounds us and allows us to exist in harmony or discord with our environment. My work may be seen as a quest for personal identity, as it

constantly asks the question, "where do 'I' fit in?" again, not as a quest for the divine, but as an understanding of place and place-making.

I choose the camera as my tool to reveal a sense of place, because it allows me to access a specific moment without drawing an immediate conclusion. The camera forces me to temporarily divorce myself from what I have seen and experienced prior to deeper reflection and evaluation once the image is printed and the dialogue between its contents and my perception begins.

Through the making of this book, I've realized that this study cannot be limited to built forms and the land they occupy only in the Southwest, but that it must be extended to other regions throughout the country. As an artist with a deeply rooted interest in how people migrate and subsequently carve spaces for themselves in their surroundings, I see this book as the first in a series documenting how people establish a sense of place—an identity—upon the land through built form.

Almost five hundred black and white images and three hundred Polaroids were taken during this road trip. The visual narrative found in this book was shaped from the notes collected and contains twenty-three Polaroid film strips illustrating the visual (temporal) sequence of each day's drive, eighty-nine black and white photographs arranged sequentially demonstrating the relationship between human-made marks and the land they occupy, and three road maps locating each photograph in context.

My photographic process has always involved an intuitive gathering of images, followed by a process of critical reflection in order to understand "why." It is as if I become part of the camera's body and can only rationalize the consequence once the camera is no longer present. I photograph that which summons my attention viscerally, only to later evaluate the reasons and meanings behind the images collected. The narratives that emerge from this process of intuitive gathering and critical reflection may be seen as a metaphor for my own emerging identity as an artist.

I photograph as my means to navigate the world and discover the infinite layers of humankind's and my own being within it. My hope is that each time you contemplate the resultant images, you, too, may come to some greater understanding of your own presence and place upon the land.

Melissa Cicetti

Albuquerque, New Mexico

Brooklyn, New York

Acknowledgments

The photographs in this book were made possible, in part, by the Stewardson Keefe LeBrun Travel Grant from the AIA New York Chapter.

I thank photographer-artists Laura Larson and Stephanie Kirk for helping me transform thirty-nine contact sheets into a photo narrative; Luther Wilson, Director of the University of New Mexico Press, for his faith in and enthusiasm for this project; Architect and Associate Professor Kramer Woodard at the University of New Mexico for his discerning eye regarding format and content; and Professor Christopher Mead Dean of Fine Arts at the University of New Mexico for his theoretical and editorial critique of the images and text.

A very special thank you goes to Barbara Buhler Lynes from the Georgia O'Keeffe Museum and Research Center for not only writing such a thoughtful Introduction, but also being such an incredible mentor and friend. Her insights and observations about my process and product were invaluable to the making of this book.

For their expertise in black and white printing, I express gratitude to Shaun Driscoll and Victoria Deser formerly of Camera Graphics Photolab in Albuquerque, New Mexico.

Finally, I extend unlimited thanks to my family and friends for supporting me and my pursuits.

Bibliography

State of Arizona, 1:500,000, United States Department of the
 Interior Geological Survey, revised 1981.

State of California, South Half, 1:500,000, United States Department
 of the Interior Geological Survey, revised 1981.

State of New Mexico, 1:500,000, United States Department of the
 Interior Geological Survey, revised 1985.